**PARK HILL** SHEFFIELD

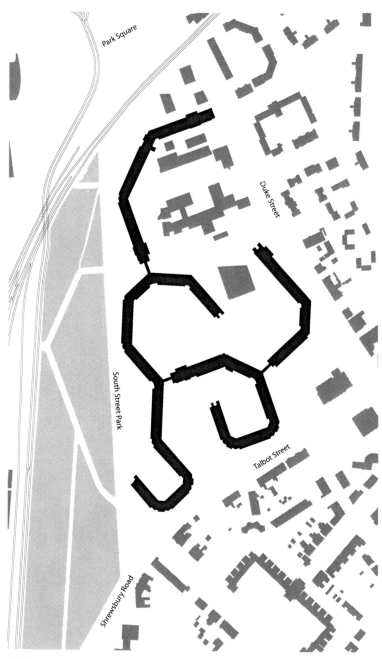

Site plan
Drawing: Laura Weafer

# PARK HILL
## SHEFFIELD

in black and white

photographs by Keith Collie

Categorical

First published in 2012
by Categorical Books | 70 Margate Road | Herne Bay | CT6 7BH

Copyright © 2012 Keith Collie and the authors

Keith Collie thanks Hawkins\Brown

'Park Hill: The Facts' was first published in *The Housing Design
Handbook: A guide to good practice*. London: Routledge, 2010
'Modernity and Order: Architecture and the Welfare State'
was first published in *Art of Welfare, Verksted 7*. Oslo: Office
for Contemporary Art Norway, 2006

ISBN 978-1-904662-17-4

A CIP record for this book is available from the British Library

**MORE AT** www.keithcollie.com
**AND** www.categoricalbooks.com

# CONTENTS

**PARK HILL** THE FACTS

David Levitt

Much has been written about this huge concrete-framed modernist scheme in the decades since its completion in 1961 and much has happened to alter the national scene in terms of social housing. When Park Hill was conceived by Ivor Smith and Jack Lynn, entirely as social housing for rent, Sheffield was near to having full employment and architects were coming up with ambitious ways of satisfying the unmet need for affordable, that is social, housing.

The facts about Park Hill – now the largest listed structure in Britain – are astonishing: 985 flats in a single deck-access complex, owing much to the then pervasive influence of the ideas of Le Corbusier, whose Unité d'habitation in Marseille had been completed only ten years earlier. The architects' vision was to create 'streets in the sky', 3.5 metres wide, every third floor. Because of the topography of Sheffield these 2 miles (more than 3km) of 'streets' connect with existing streets at their southern end. And Park Hill was not only equipped with district heating but it also boasted the Garchey system of centralised refuse disposal.

It was held in popular and critical esteem for 20 years, but the prejudice against large-scale, modernist, concrete-faced, mono-tenure estates eventually caught up even with this internationally celebrated building. While its popularity waned, however, it was listed Grade 2* in 1998 and in

2004 a competition was held to determine its future. This was won by Urban Splash, which had established itself as a highly successful and innovative developer, with Hawkins\Brown and Studio Egret West as architects.

Since 1990 the policy for the southern half of England had been to persuade developers and their customers to accept the principle of mixing tenures as indistinguishably as possible. However, Urban Splash had built its reputation on developments containing very little affordable accommodation in the city centres of Manchester and Liverpool, where it was considered that there was already an imbalance in favour of affordable rented homes. At Park Hill, Urban Splash's proposals involved 'pepperpotting' a third of the new accommodation with homes for affordable rent, stripping the original flats and maisonettes back to the concrete crosswall structure and replacing each cluster of four flats (consisting of a one-bed, two two-beds and a three-bed maisonette) with an ingenious five-flat cluster containing more small units. The recession of 2008–9 caused the developer to reconsider its original choice of apartment size, reverting to a mix more closely resembling the original but retaining the same division of tenures.

Another of the most contentious issues, that of managing mixed-tenure housing, is likely to be overcome at Park Hill with the incorporation of a 24-hour concierge. In the first phase there are 85 flats served off each of three cores and approximately this ratio will be maintained across later phases. Each core will have a secured lobby at ground level and a main 24-hour concierge will operate from the new stair and lift core adjacent to the four-storey 'cut' in the middle of the north block, which is likely to remain the principal concierge point for all the phases. The concierge will monitor comings and goings from all cores and will also collect parcels and large deliveries adjacent to the main lobby. Letter post

will be delivered to each front door, distributed traditionally along each street by the Post Office.

The proposals for Park Hill include the construction of a new multi-storey car park to increase the provision from 20 to 72 per cent and this will also be placed under the control of the concierge.

Apart from the concrete superstructure, what is being reused? It is intended to employ as much of the existing infrastructure as possible. The Sheffield District Heating System will continue to provide hot water to the whole of Park Hill and the existing service trench and risers will also be reused – the original planning of the building allows for efficient and fairly flexible reuse. New incoming and outgoing pipework will be needed, but the distribution will be the same.

Obviously this is a costly refurbishment given the requirements for the concrete frame to be repaired (in line with English Heritage's requirements for a Grade 2* listed building) and the costs of protecting the frame during a complex partial demolition of the existing façade and its replacement by a thermally efficient external skin. It should, however, represent a triumphant saving in terms of embodied energy and continue Park Hill's established reputation as one of the principal landmarks of central Sheffield for many generations to come.

ARCHITECTS Hawkins\Brown and Studio Egret West
DEVELOPERS Urban Splash Limited with Sheffield City Council
FUNDERS Sheffield City Council | HCA | Great Places Housing Group | English Heritage
SITE 13.29 hectares
NUMBER OF DWELLINGS 985 (originally)
DENSITY 69 dwellings/hectare
MIX not finalised
PARKING SPACES PER DWELLING 0.72 (originally 0.2)
NON-HOUSING USES 6000 square metres of retail, community and medical facilities

Layout plan
Drawing: Laura Weafer

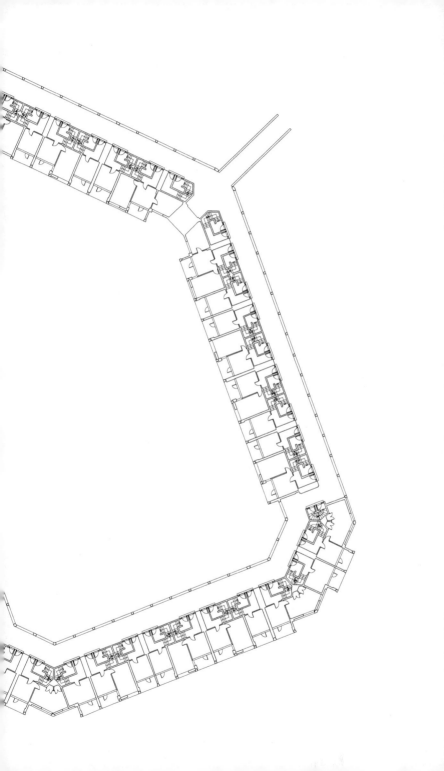

# MODERNITY AND ORDER
## ARCHITECTURE AND THE
## WELFARE STATE

**Jeremy Till**

'The way we define the poor is a reflection of the
kind of society we live in.' **Zygmunt Bauman**

**I want to start and end this essay with stories. The first goes
like this:**

I am on a visit to the McLaren Headquarters designed by Norman Foster
to house the production facilities, offices and associated spin-off
companies of the Formula One racing group. Many people are saying
that this is Foster's ideal project: a heady mix of technology transfer,
undisclosed (i.e. huge) budget, speed, minimal tolerances, Vorsprung
durch Technik, male hormones and a client (Ron Dennis) who is famously
perfectionist and famously demanding. There was a danger that he and
Norman (who is thought to share these qualities) might clash, but they
are now firm friends (the building is a success). The two even share the
same birthday. How spooky is that? They make cars here, but do not
think grease monkeys and porn calendars. Think white gloves and
sterile laboratories. I joke that the specification for the cleaning contract
must be longer than that for the building contract, but am met with stony
faces. Neither do I get many laughs when a group of silhouetted
muscles in black uniforms approach us and I ask if they have come off
the production line as well. I was beginning to lose patience by then,
a decline hastened by a remote-control dispenser that had gone
berserk and sprayed liquid soap over my expensive new shirt. It was
not just my suppressed anger at the senseless waste of the whole
operation, boys with toys in a sport that effectively sanctioned global

[Fig. 1]

**13**

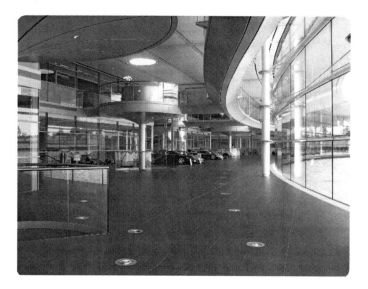

Fig. 1 McLaren Headquarters, 2005 | Architect: Foster + Partners.
Photo: Jeremy Till

warming. It was not just that the exhibited cars had a better view than the workers. It was more that there was something deeply disturbing about the silence, the absolute control and the regime of power that the architecture asserted. 'Don't the engineers mind being seen and watched?' I ask of the huge windows that put the whole process on display. 'They get used to it,' comes the terse reply that for once eschews the techno-corporate spin used to justify the rest of the building ('Ronspeak' as petrolheads affectionately call it).

On emerging from the building, a debate starts. I was left gasping at the vision of a dystopian future of spatial authority through suppression, as they marvelled at the transfer of carbon-fibre technology from car body to staircase detail. My reaction was visceral and when I tried to explain my views on the building, it came out as pure emotion. This was a problem. They came back with a reasoned argument as to why the building was a near-perfect marriage of form and technique. They won, as reason always wins over emotion. Stands to reason, dunnit?

I start with Norman Foster as an image of the will to order that has pervaded architecture since its very beginnings. The normal route for architectural theory sets out from a fairly obscure Roman author, Vitruvius, and his *Ten Books of Architecture.* 'I decided,' Vitruvius writes with a certain lack of modesty, 'that it would be a worthy and most useful thing to bring the whole body of this great discipline to complete order.' The ambitious task of calling the discipline to complete order applies not just to the body of professionals – Vitruvius gives precise instructions as to what should be included in an architect's education – but extends to the products of that discipline. 'Architecture,' he writes, 'depends on *ordinatio*, the proper relation of parts of a work taken separately and the provision of proportions for overall symmetry.'[1]

Here we have the first conflation of the values of profession, practice and product that is to be repeated throughout architectural history: a prescription of order that applies equally to the knowledge of the profession, the structure of practice and the appearance of buildings. Right from the beginning we get the identification of the architecture as an act of imposing order, of taking the unruly and making it coherent. However, this is not an aesthetic act alone in terms of ratio and symmetry. Vitruvius had greater ambitions than simply defining taste. 'I realised,' he writes in the preface directed to the Emperor Augustus, 'that you had care not only for the common life of all men and the regulation of the commonwealth, but also for the fitness of public buildings – that even as, through you, the city was increased with provinces, so public buildings were to provide eminent guarantees for the majesty of empire.' What is happening here is that under the more-or-less benign cloak of aesthetic codes, Vitruvius is slipping in a distinctly non-benign association with social reform and imperial power. The term 'ordering' all too easily conflates the visual with

1 The Vitruvius quotes are from the translations in Indra Kagis McEwen, *Vitruvius: Writing the Body of Architecture* (Cambridge, Mass: MIT Press, 2003), 17, 65.

the political. Just because he was first does not necessarily make him right, but it certainly makes Vitruvius influential, because the mistaken (and dangerous) conflation of visual order with social order continues to this day.

In *Civilization and Its Discontents*, Sigmund Freud famously identifies beauty, cleanliness and order as occupying 'a special position among the requirements of civilization'.[2] We have just identified the combination of beauty and order in the Vitruvian legacy. Cleanliness adds another dimension: it denotes purity, the removal of waste, whiteness. It is not for nothing, therefore, that modernist architectural beauty is so often associated with pure forms, elimination of decoration, and white walls.[3] And it is not for nothing that this cleanliness is so often associated with some kind of moral order made possible by the actions of the architect/artist. This is a theme from Plato – 'The first thing that our artists must do... is to wipe the slate of human society and human habits clean... after that the first step will be to sketch in the outline of the social system'[4] – to Le Corbusier: 'A COAT OF WHITEWASH. We would perform a moral act: *to love purity!*... whitewash is extremely moral.'[5] In the rush of words, we overlook the offensiveness of the association of visual purity with social morality.

The three terms – beauty, cleanliness and order – form a triangle, in fact a Bermuda triangle that eliminates anything that might threaten its formal (and social) perfection. Thus alien objects, dirt, the low, the supposed immoral, are cast aside in the pursuit of purity. Le Corbusier often describes the pre-modern city as having an illness, normally cancer, which must be cut out if the principles of purity and order are to be effected. If the 'city has a

2 Sigmund Freud, *Civilization and Its Discontents* (London: Penguin, 2002), 40.
3 See Mark Wigley's exhaustive survey of whiteness, fashion and cleanliness in modern architecture: Mark Wigley, *White Walls, Designer Dresses* (Cambridge, Mass: MIT Press, 1995).
4 Section 501a of *The Republic*. Plato, *The Republic*, trans. Desmond Lee (London: Penguin, 1974), 237.
5 Le Corbusier, *The Decorative Art of Today*, trans. James Dunnett (London: Architectural Press, 1987), 188, 92.

biological life'[6] which has been infected by illness, then order can only be effected through radical surgery; the primary care of medicine will not suffice: '*in city planning "medical" solutions are a delusion; they resolve nothing, they are very expensive. Surgical solutions resolve.*'[7] Corbusier's metaphor is telling. The stigma of sickness must be eradicated, cancerous elements cut out, if a fresh start is to be made. Only then can the quest for ordered perfection be initiated. The Bermuda triangle again: purity, cleanliness and order eliminating and excluding the rogue objects. 'Orderly space is rule-governed space,' Zygmunt Bauman writes, and 'the rule is a rule in as far as it forbids and excludes.'[8]

When Bauman refers to the 'surgical stance that throughout the modern age characterised the attitudes and policies of institutionalised powers,'[9] we can begin to understand that Le Corbusier's excising proclamations are not just the rantings of a self-promoting polemicist but part of a more general attitude. Le Corbusier is seen in the wider picture not as the inventor of modernism, but as an inevitable consequence of modernity.[10] He is a symptom not a cause (whereas in most conventional architectural histories he is seen as a harbinger of the change that modernism will bring about). Bauman and other social theorists allow us to see that the principles of architectural modernism fit the more general pattern of the will to order that Bauman identifies as a central feature of moder-

6 Le Corbusier, *When the Cathedrals Were White: A Journey to the Country of the Timid People*, trans. Francis Hyslop (London: Routledge, 1947), 50.

7 Le Corbusier, *Précisions*, trans. Edith Schreiber Aujame (Cambridge, Mass: MIT Press, 1991), 172.

8 Zygmunt Bauman, *Wasted Lives* (Cambridge: Polity Press, 2004), 31.

9 Zygmunt Bauman, *Modernity and Ambivalence* (Cambridge: Polity Press, 1991), 99.

10 Hilde Heynen's explanation of the difference between modernity (as a societal condition) and modernism (as an artistic and intellectual expression) is useful here: 'Modernity here is used in reference to a condition of living imposed upon individuals by the socio-economic process of modernisation. The experience of modernity involves a rupture with tradition and has a profound impact on ways of life and daily habits. The effects of this rupture are manifold. They are reflected in modernism, the body of artistic and intellectual ideas and movements that deal with the process of modernisation and with the experience of modernity.' Hilde Heynen, *Architecture and Modernity: A Critique* (Cambridge, Mass: MIT Press, 1999), 1.

The terms are also explored in Marshall Berman, *All That Is Solid Melts Into Air: The Experience of Modernity* (New York: Viking Penguin, 1988), 16.

nity. Of all the 'impossible tasks that modernity set itself... the task
of order (more precisely and most importantly, of order as task)
stands out.'[11] Thus Bauman's argument that 'the typically modern
practice... is the effort to exterminate ambivalence,'[12] puts into con-
text Le Corbusier's Law of Ripolin with its 'elimination of the equiv-
ocal.'[13] Bauman describes the modern age as one that has a 'vision of
an orderly universe... the vision was of a hierarchical harmony
reflected, as in a mirror, in the uncontested and incontestable pro-
nouncements of reason.'[14] The ordering of space can thus be seen as
part of a much wider ordering of society. Depending on whose argu-
ment you follow, architects are mere pawns in an overwhelming
regime of power and control, or else architects are active agents in the
execution of this power and control.

There are two key, and interrelated, aspects of Bauman's anal-
ysis of modernity and its ordering tendencies. On the one hand, he
argues that the will to order arose out of a fear of disorder. 'The kind
of society that, retrospectively, came to be called modern,' he writes,
'emerged out of the discovery that human order is vulnerable, con-
tingent and devoid of reliable foundations. That discovery was
shocking. The response to the shock was a dream and an effort to
make order solid, obligatory and reliably founded.'[15] The important
word here is 'dream'. The possibility of establishing order over and
above the flux of modernity is an illusion. It is an illusion because of
the second aspect of his argument, namely that to achieve order one
has to eliminate the other of order, but the other of order can never
be fully erased. 'The struggle for order... is a fight of determination
against ambiguity, of semantic precision against ambivalence, of
transparency against obscurity, clarity against fuzziness. The other
of order is not another order: chaos is its only alternative. The other

11 Bauman, *Modernity and Ambivalence*, 4.
12 Ibid., 7.
13 Le Corbusier, *The Decorative Art of Today*, 192.
14 Zygmunt Bauman, *Intimations of Postmodernity* (London: Routledge, 1992), xiii.
15 Ibid., xi.

of order is the miasma of the indeterminate and unpredictable. The other is the uncertainty, that source and archetype of all fear.'[16] The gardener gets rid of weeds as part of the controlling of nature. As we shall see with architecture, as with any project of the modern age, the more one attempts to eliminate the other of order, the more it comes back to haunt one. Weeds always come back. The whiter the wall, the quicker it succumbs to dirt. In their pursuit of an idea (and an ideal) of order, architects have to operate in a state of permanent denial of the residual power of the other of order.

So, it is clear that the ordering tendencies of architectural modernism elide seamlessly with the ordering tendencies of modernity. There are two main sites where this happens: firstly through the international style of corporate modernism, and secondly through the architecture of the welfare state. In the case of the latter there is a symbiotic relationship; both the welfare state and architectural modernism are reliant on their need for order. Within the welfare state, the poor need to be reclassified as non-poor if progress is to be announced. They need to be reordered into another system, lifting them from poverty in an attempt to throw off the Victorian associations with dirt and immorality. Importantly, it needs to be seen that the poor have been reordered, and it is here that architectural modernism comes in as a signifier of order, cleanliness and progress. And architecture is all too willing to collaborate, not just because the welfare agenda fits so well with architecture's own agenda of ordering and cleanliness (with 'beauty' in there as an associated given), but also because architects can *feel good about it.*

Architecture's relation with the social and political world has always been ambivalent. This is not to say that architecture is not inherently social and political, but architecture as a discipline has always been uncertain to the point of retreat about its role. Hence

16 Bauman, *Modernity and Ambivalence*, 7.

the tension between seeing architecture as an autonomous disci-
pline where it can assume a false strength on its own terms, or seeing
architecture as an act of engagement with wider forces, with all the
associated danger of losing that internal strength. The retreat to
autonomy is the more attractive option, which is why architectural
attempts at social ordering so often end up in naïve attempts at
redemption through beauty or else wholesale failure in the form of
all-or-nothing utopias. The architecture of the welfare state provides
a perfect vehicle for architectural notions of social progress being
effected by architectural input. The rhetoric of the welfare state is
always hopeful, even if the reality is somewhat different.

The architecture of the welfare state is a perfect opportunity
for architects to work through their social conscience while getting
on with what they really want to do. It provides a cover of goodness
under which they can sneak in all the old arguments about progress
and order. This is most clear in the strand of modernism known as
'humane modernism' that is particularly associated with the archi-
tecture of the welfare state in 1930s' and 1950s' Scandinavia. The use
of the word 'humane' in front of another word should always raise
suspicion: humane methods of killing, humane farming, humane
systems of asylum management and (for a contemporary twist on
torture) humane methods of interrogation. In all of these the word
'humane' is an attempt to soften the guilt of the term it is attached
too, and so it is with humane modernism. The humaneness is a skin
of softness and 'beauty' that serves to cover the hardness of the
underlying modernist sensibility.

Of all the ordering traits that are most clearly brought to
bear in the architecture of the welfare state, it is functionalism that
is the most telling. Functionalism, and its even more determinist
partner behaviourism, turns the users of buildings into abstrac-
tions. This is all too convenient for the architects and sociologists
of the welfare state, because it removes those users from the reality

of their social condition and allows them to be *operated* on (recalling the previous medical metaphor). I am not suggesting that we are talking Dr Death here. Architects are, or at least like to think of themselves as, liberal optimists set with the belief of making the world a better place. The trouble is that notions of redemptive beauty and determinist functionalism mean that those aspirations are misplaced. The functionalism of the welfare state is a mechanism for reordering behaviour: in the white, light-filled, spaces of 'humane' modernism you will behave properly. The paternalism of the welfare state is spatialised in the frozen spaces of our social housing, hospitals and schools.

But there is a problem, a big problem. People are not abstractions. They do not submit to the reason of functionalism; they have emotions, lives, accidents, and politics. The space of abstraction cannot accommodate the spatiality of being – by which I mean (following Henri Lefebvre) the sociality of being. And so the architecture of the welfare state begins to show the strain as the contingency of life begins to undermine the order of the frame that holds it, and this in turn becomes the spatialisation of the failure of the welfare state: those sad housing projects, crumbling hospitals and incompetent schools that only forty years on are now being replaced, failed dreams of an impossible order. Bauman, as we have seen, is quite clear about this: the other of order can never be ridded. Waste, dirt, contingency all come back to haunt the unattainable illusions of the modern project, be it architectural modernism or the welfare state. Bauman's famous statement that postmodernity is 'modernity without illusions'[17] is a summary of his argument that the age of postmodernity is not a break, not something that is *after* modernity, but something that is the reality of modernity, in which contingency, uncertainty and lack of control are inevitable conditions which we have to face.

17 Zygmunt Bauman, *Postmodern Ethics* (Oxford: Blackwell, 1993), 32.

I want to illustrate the impossibility of the modern project through the example of Park Hill flats in Sheffield, one of the shining and iconic symbols of the 1960s welfare state and of the architecture of the welfare state. This building, now the largest listed building in Europe, is best explained through two parallel histories: the 'official' architectural story, in all its autonomy and aspirations of perfection, and another other (full of anecdote, gossip and populism) which is the unofficial story that upsets and subverts the first story.

When Park Hill was finished, The Architectural Review devoted a whole issue to the architecture of Sheffield. It was a shining beacon of architectural optimism. Architects would come from across Europe to see this herald of a brave new world in which modernism had finally achieved its social potential. Years later, the building is listed for its social and architectural significance. It [Fig. 2] must now stay.

For years the local paper, The Sheffield Star, has waged a campaign against Park Hill, a campaign that reached fever pitch when the building was listed. For the Star, Park Hill conflated concrete, ugliness, tower blocks (though it is by no means vertical), architects with penis complexes, social decay, more concrete, drug abuse, family breakdown, broken lifts into a single vision of horror. The fact that the horror is so central and visible in Sheffield adds further indignity. Park Hill is effectively, for the Star, staining the city. It must go.

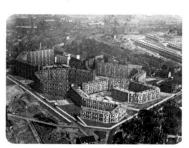

Fig. 2 Park Hill under construction in 1961.
Photo: RIBA Library Photographs Collection

# PARK HILL SHEFFIELD

The father of Park Hill was the City Architect of the time, Lewis Womersley, who had the vision (and guts) to delegate the job to two young architects fresh out of university, Jack Lynn and Ivor Smith. There is a famous picture of Womersley photographed from below, framed by the two blocks of Park Hill. He elides with the [Fig. 3] building. It is his.

I once met the former Labour Minister Roy Hattersley at a party. He explained at some length how he was the Chair of the Housing Committee of Sheffield City Council when Park Hill was being planned. It was very much his baby.

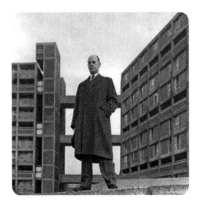

Fig. 3 Park Hill, Sheffield, with Lewis Womersley, Chief Architect of Sheffield City Council.
Photo: Sam Lambert | Architectural Press Archive | RIBA Library Photographs Collection

The architectural history of Park Hill tends to gloss over the contribution of the social worker Mrs Demmers, who worked tirelessly with the people who were being moved from the old slums to the new flats. She ensured that neighbours from the old streets were relocated next door to each other in the new 'streets in the air'. The resulting sense of social continuity was seen be a major contribution to the initial success of the project.

Park Hill replaced the notorious slums of the Manor, smoke-stained back-to-back terraces with little sanitation. The architecture of Park Hill effected the change from a place of social and physical despair to a place of social and physical hope.

In the introverted world of architectural history, the streets in the air of Park Hill are deemed to be direct descendants of the Smithsons' Golden Lane competition entry (unbuilt but highly influential at the time). One endlessly reproduced image by the Smithsons suggests that streets in the air can be places of social interaction, recreating the dynamic of the original street but with none of the intrusions of traffic or rain.

The elevations of Park Hill are made up of a concrete frame infilled with brickwork. Originally the bricks lightened in colour from bottom to top, giving a variation and levity to the whole. One critic (OK, it was me on a poetic day) describes it as having the quality of cliffness. The effect of the frame versus the infill is to hold multiple visions of everyday life together in coherent manner, allowing traces of the domestic to come to the surface.

Following a zero-tolerance sweep-up of Burngreave, one of the toughest areas of Sheffield, the drug gangs moved down to Park Hill. They found the streets in the air perfect for dealing – being able to survey from above when police were coming and scarpering along the streets to disappear down one of the many staircases. Proximity to the station made it all the more convenient.

Park Hill has all the attributes of failure that Alice Coleman lays at the door of modernist architects in her disgraceful book Utopia on Trial.[18] Disgraceful, because the argument shifts the responsibility of social deprivation from society to the built form in a semi-determinist manner. It is not the politician's fault, it is the architect and planner's fault. Small wonder that Coleman was one of Margaret Thatcher's favourite academics.

---

18 Alice Coleman, *Utopia on Trial: Vision and Reality in Planned Housing* (London: Hilary Shipman, 1985).

When Park Hill was built, the housing wrapped around an infrastructure of public facilities: a school, three pubs, and a shopping centre. It was [Fig. 4] conceived of as a small town.

Over the years, as the spending power of the tenants of Park Hill declined, the facilities closed down. There is now one pub, a small supermarket with bars on the windows, a few marginal shops and a take-away that specialises in curried sausages.

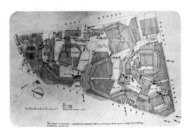

Fig. 4  Park Hill, site plan.
Sheffield Archives | Acc. No. 1986/10

The clustering of the flats in Park Hill is often seen as one of its most innovative design features. A single walkway serves three storeys of flats, most of which are duplexes. One drawback of the concentration of staircases and entrance doors off the street is that there are no windows overlooking the street. This is the major flaw in the design, because the traditional street depends on a relationship between house and street, with the windows acting as a visual link so that the boundary of street and house is blurred. With no such blurring, the street at Park Hill is not visually 'owned' by anyone, and therefore loses the aspects of security and community that are found in the traditional street.

I used to live in Park Hill. Florence lived three doors down from me. She had lived in Park Hill right from the beginning, and her forty years of residence had made her ferociously loyal to the place. Every day she came out and mopped the street outside her front door, sticking precisely to the width of her flat. As one walked the grubby street with its stained asphalt surface, one crossed this shining width. In this way Florence claimed that bit of street as her own, an extension of her realm.

A combination of housing policy, general decay, stigma and (according to some bigots) the influx of asylum seekers, meant that by 2003 the future of Park Hill was looking bleak. There was a campaign to have it pulled down, but its heritage status made that impossible. So the Council entered into a deal with the developers Urban Splash to regenerate the whole complex. They plan a mixture of social housing and private-sector housing, a whole array of shops and a hotel. To launch the project they made a compelling video and printed T-shirts: 'J'aime Park Hill'.

I am at a party in Manchester. One of the key members of the Urban Splash team comes up to me. 'Jeremy,' he says, waving his arms in excitement, 'Jeremy, our aim is to make Park Hill sexy! Then we will have succeeded.'

This last story is indicative of where we have come to with the welfare state, or to be more precise with the demise of the welfare state. No one would ever have tried to defend the architecture of the welfare state in terms of its sexiness. We have effectively moved from an era of welfare to an era of consumption, and the architecture of Park Hill must follow suit. As Bauman notes:

> ... the recently popular 'welfare to workfare' schemes meant to make the welfare state redundant are not measures aimed at improving the lot of the poor and unprivileged, but a statistical exercise meant to wipe them off the register of social, and indeed ethical, problems through the simple trick of reclassification.[19]

19 Zygmunt Bauman, *The Individualised Society* (Cambridge: Polity Press, 2001), 75.

The poor are redesignated as working consumers, albeit with little money to spend but at least no longer in official need of welfare. Those who do not make it over this line are left behind as the so-called underclass who exist outside the rules of the consumer society and are thus ostracised and demonised: the asylum seekers, ASBO holders,[20] foreign and illegal workers on less than the minimum wage, prisoners, and the pensionless old (thrown a yearly bait of winter fuel allowance to keep them quiet). They need to be placed out of sight, out of mind, and in this state fall beyond the remit of the previous welfare state. 'In a world populated by consumers,' argues Bauman, 'there is no room for a welfare state. That venerable legacy of industrial society looks suddenly much like a "nanny state", pampering the slothful, coddling the wicked, abetting the corrupt.'[21]

What is revealing is quite how quickly the architecture has readjusted to this new state of affairs. On the one hand patients and school children are now no longer the recipients of welfare but the consumers of services. This is manifested in the delivery of our new hospitals and schools through the private sector to create service spaces dictated by the demands of the marketplace. The architecture of this new welfare state of consumption is of course that of corporate capitalism, with hospitals indistinguishable from office blocks and schools – now designated as city academies – the same [Fig. 5] as business parks. Modernism rears its ugly head of beauty again. And then there is the architecture of the underclass. Prisons, asylum-seeker centres, old-people's homes and housing for the new poor all housed in ghettos with the strictly functionalist aspect of modernism rearing its head again. To illustrate this, I want to end with another story:

20 ASBO stands for 'Anti-Social Behaviour Order', a system of control introduced by the Labour government to deal with the perception that certain areas of the UK had descended into a form of social anarchy.
21 Zygmunt Bauman, *Work, Consumerism and the New Poor* (Buckingham: Open University Press, 1998), 91. See also Peter Abrahamson, 'Liquid Modernity: Bauman on the Welfare State', *Acta Sociologica* 47, no. 2 (2004), from whom my argument in this section is taken.

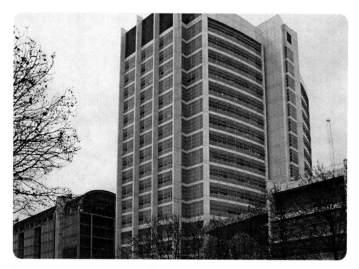

Fig. 5 UCL Hospital on the right, new offices for the Wellcome Trust on the left.

In the backyard of the London Borough of Islington in an area of existing housing, the local Council have seen fit to erect a huge rubbish dump. Well, that is what I will call it as long as it smells and casts stigma. Rubbish is indeed dumped there, and then taken away later. The Council are, of course, aware of the stigma of rubbish and therefore officially designate the building a 'waste transfer station', as if the word transfer will signify a transient state of waste always on the move, and in this transience make it more acceptable. If you go round to the local agents trying to flog the new apartments up the road from the 'station', they have another spin on it. Ask them, pretending to be a prospective purchaser, 'what about the rubbish dump?', and they throw their hands up in horror: 'No, no, no, it is a recycling facility', as if, as if you will be buying into some sustainable lifestyle with associated feelgood factor.

But these agents are not selling the apartments that actually wrap around the station. Initially the developers tried the argument that 'the new facilities can take their place in the city in a way which reflects pride in the provision of public services.'[22] The subsequent outcry of the

22 This is, almost unbelievably, a quote from the 'urban design statement' submitted by the developers, Arsenal Football Club, in support of their application for planning permission. The authors of this quote are not precisely identified, but guilty by association are the named urban designers, East, and the architects for the rubbish tip and associated housing, Sheppard Robson.

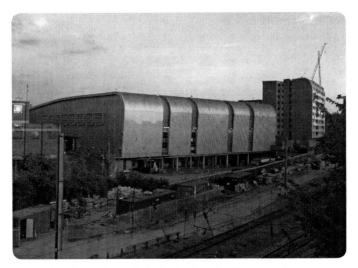

Fig. 6 Lough Road Waste Transfer Station, London Borough of Islington, 2006.
Tipping yard with housing in the background.
Photo: Jeremy Till

local community suggested that the developers' faith in public pride was misplaced when it came to rubbish dumps. So the scheme was redesigned and the dump hidden away behind a wall of housing which wrapped around all its most visible sides. The out-of-sight, out-of-mind argument appeared to sway the Council who then gave the go ahead (over the still-vociferous complaints of the locals who knew that out of sight was not out of stigma, let alone out of nostril).

[Fig. 6]     One result is a block of flats with one side overlooking the rubbish-tipping yard, the next against the main East Coast Railway line, the next hard up against the Caledonian Road, and the last overlooking the access road up which 400 rubbish trucks pass every day. This housing is not for sale because it is designated for 'keyworkers': nurses, teachers, firemen, and maybe even rubbish collectors. This new underclass will live their lives quite literally with their backs up against a wall of waste. This is the spatialisation of the new welfare state. Rubbish tip, rubbish people, all rubbish, always will be. Call it a waste transfer station, call it a recycling facility, but words don't rub out rubbish. Rubbish is immortal.

This is a somewhat despairing vision to end on, the more so because it is happening not just in my backyard but in all of our backyards. As an architect I feel helpless in the face of this reality. The solution, clearly, is not architectural. The notion of redemption through order, beauty and cleanliness is hopeless, but still a notion to which architects cling: as they become increasingly marginalised they go back to their Vitruvian roots, citing 'commodity, firmness and delight' as a mantra and becoming little more than, in Tafuri's phrase, 'gymnasts in the prison yard'. My partial, very partial, response as an educator of architects is to repoliticise architecture and to accept its fragility in the face of contingent forces. To act modestly and partially and politically, making small moves towards a slightly better place rather than large moves towards a reinvented world. This demands a move away from the strictures of order, so that architecture, far from being a straitjacket for social control, becomes a crucible for social exchange, in which contingency is not seen as a derided threat but as an opportunity.[23]

23 These arguments are developed in my book, *Architecture Depends* (Cambridge, Mass: MIT Press, 2009).

Abrahamson, Peter. 'Liquid Modernity: Bauman on the Welfare State',
        *Acta Sociologica* 47, no. 2 (2004), 171–79.
Bauman, Zygmunt. *Intimations of Postmodernity.* London: Routledge,
        1992.
        *Modernity and Ambivalence.* Cambridge: Polity Press, 1991.
        *Postmodern Ethics.* Oxford: Blackwell, 1993.
        *The Individualised Society.* Cambridge: Polity Press, 2001.
        *Wasted Lives.* Cambridge: Polity Press, 2004.
        *Work, Consumerism and the New Poor.* Buckingham: Open
        University Press, 1998.
Berman, Marshall. *All That Is Solid Melts Into Air : The Experience of
        Modernity.* New York: Viking Penguin, 1988.
Le Corbusier. *Précisions.* Translated by Edith Schreiber Aujame.
        Cambridge, Mass: MIT Press, 1991.
        *The Decorative Art of Today.* Translated by James Dunnett. London:
        Architectural Press, 1987.
        *When the Cathedrals Were White: A Journey to the Country of the
        Timid People.* Translated by Francis Hyslop. London: Routledge,
        1947.
Freud, Sigmund. *Civilization and Its Discontents.* London: Penguin, 2002.
Heynen, Hilde. *Architecture and Modernity: A Critique.* Cambridge, Mass:
        MIT Press, 1999.
McEwen, Indra Kagis. *Vitruvius: Writing the Body of Architecture.*
        Cambridge, Mass: MIT Press, 2003.
*Plato. The Republic.* Translated by Desmond Lee. London: Penguin, 1974.
Wigley, Mark. *White Walls, Designer Dresses.* Cambridge, Mass: MIT Press,
        1995.

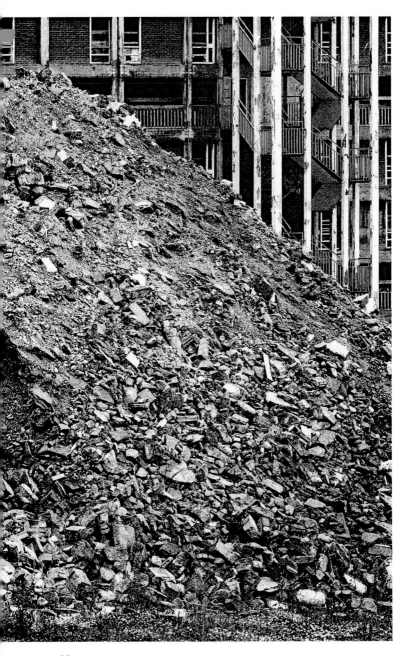

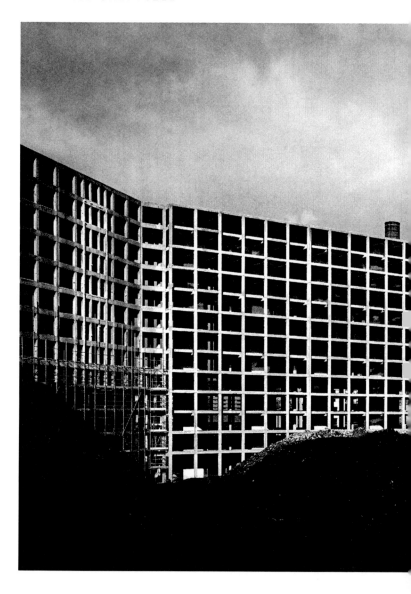

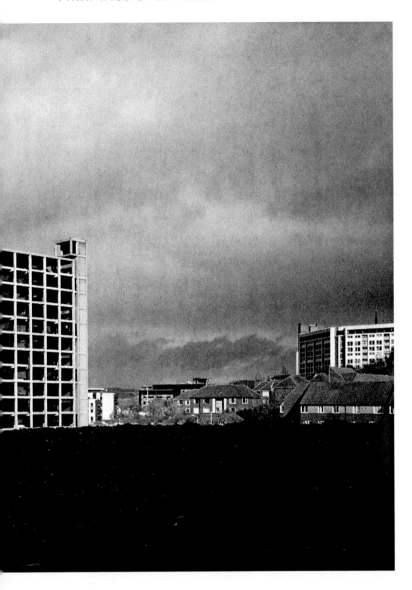

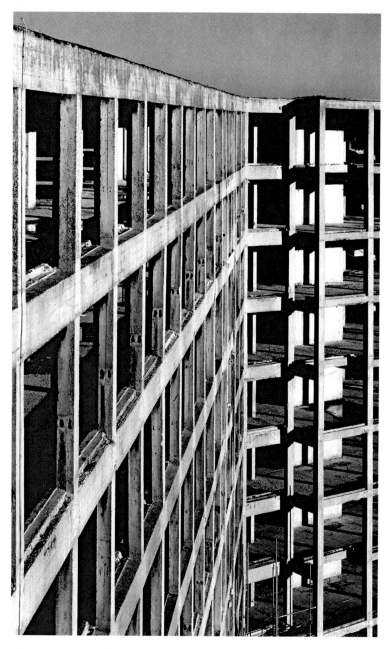

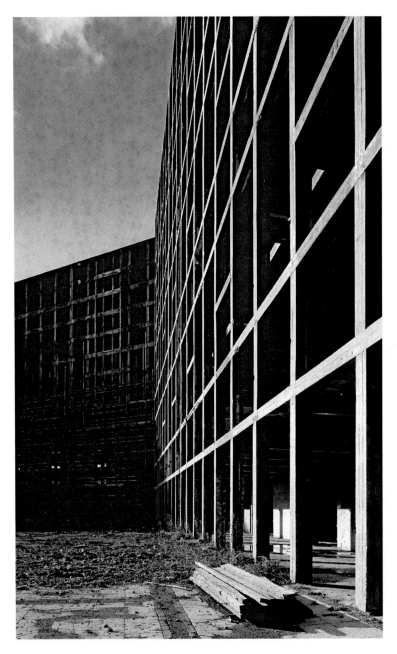

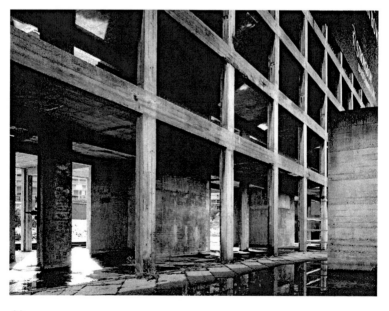

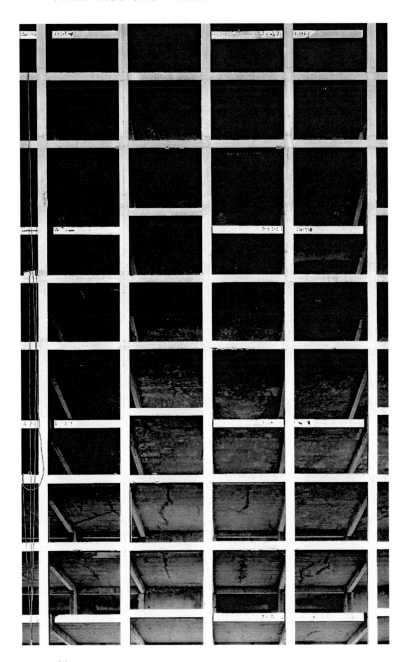

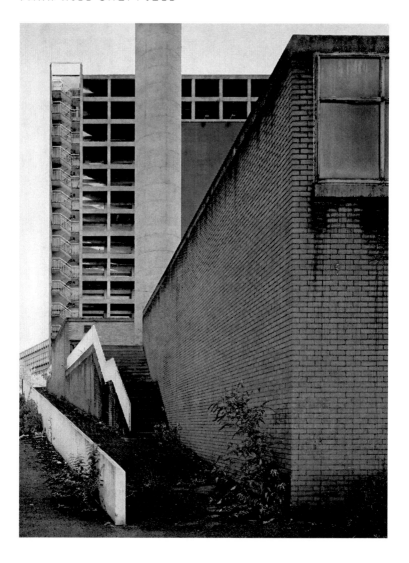

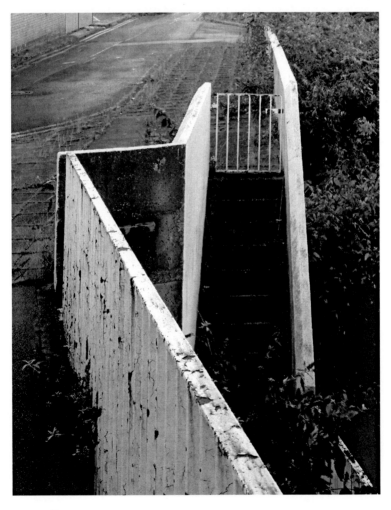

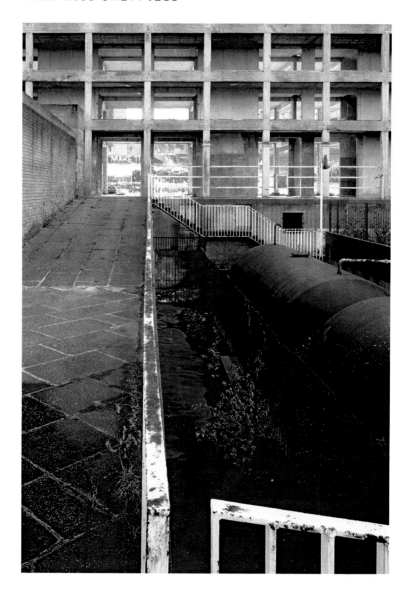

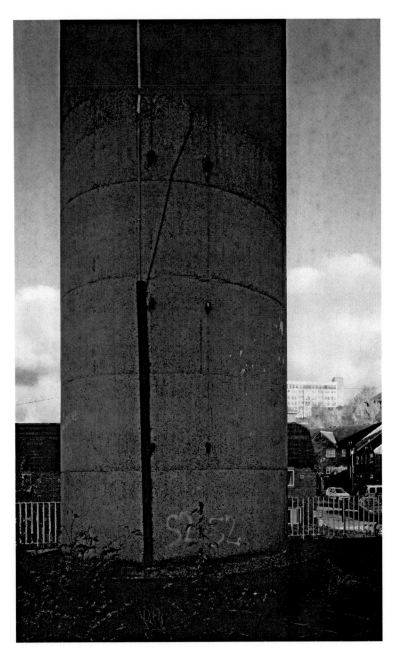

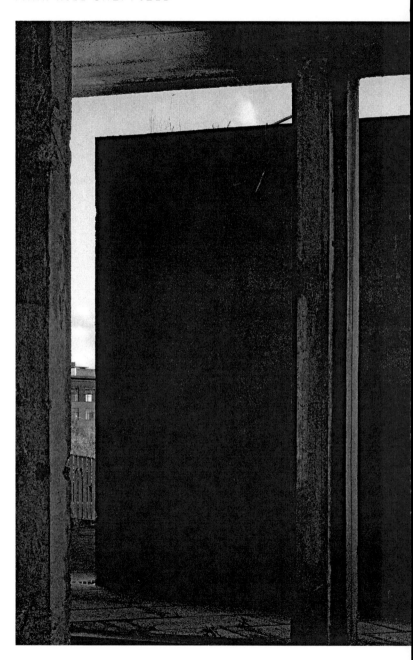

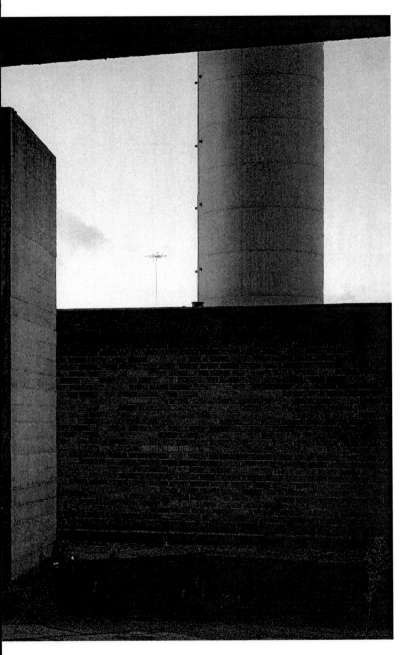

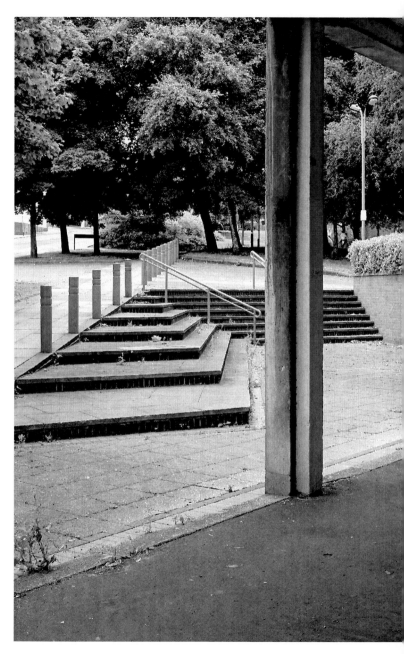

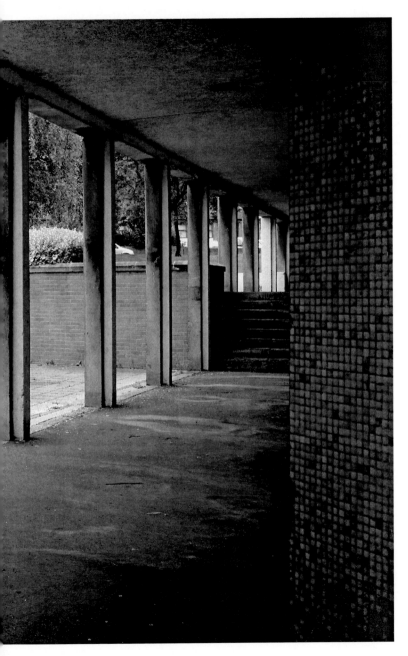

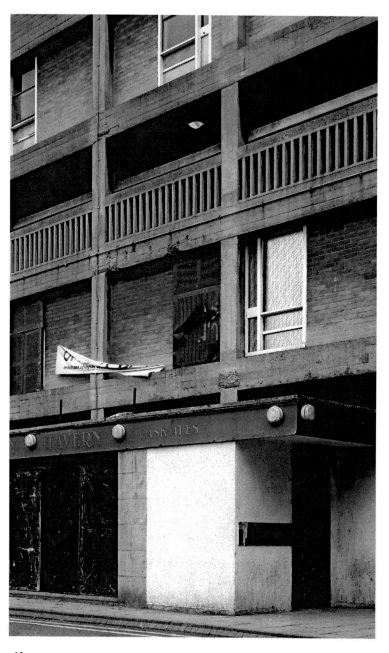

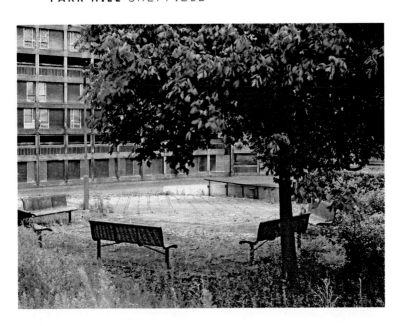

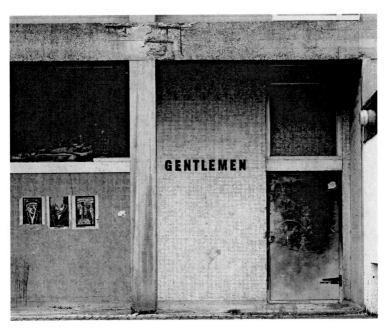

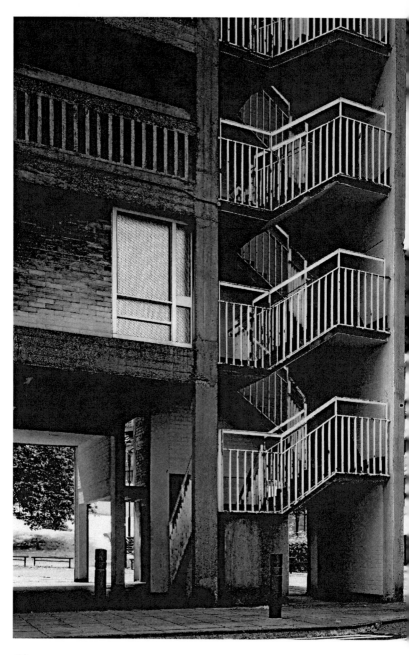

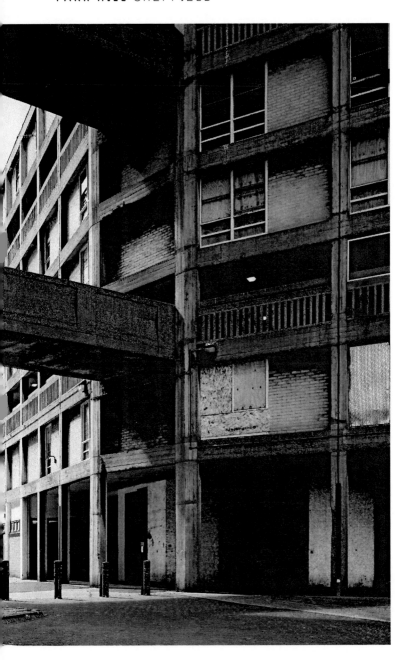

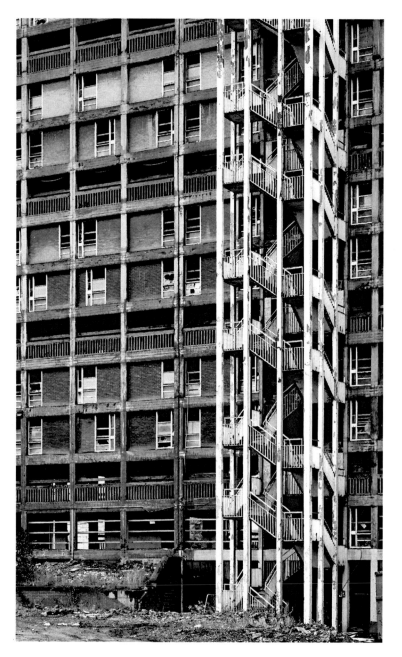

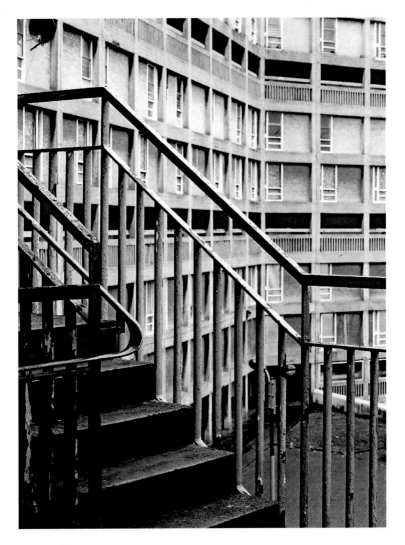

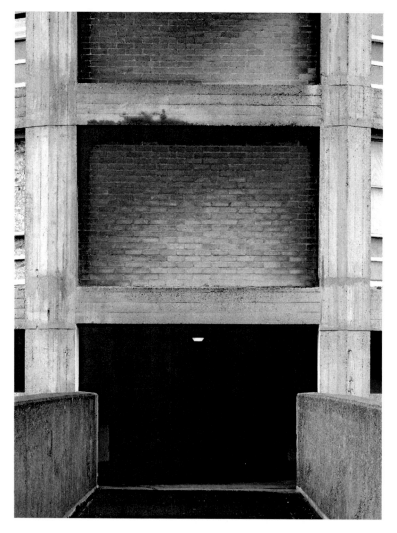

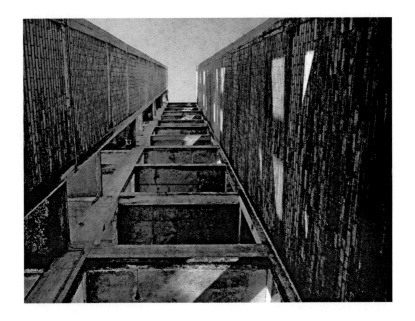

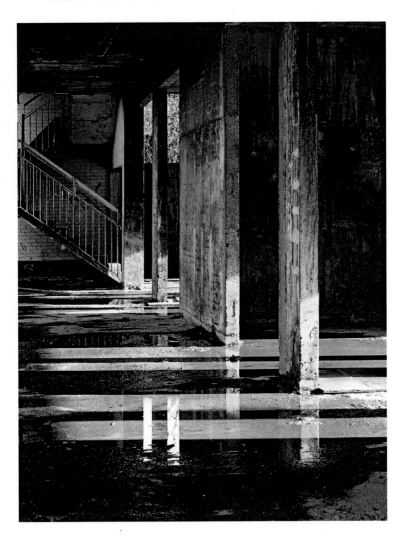

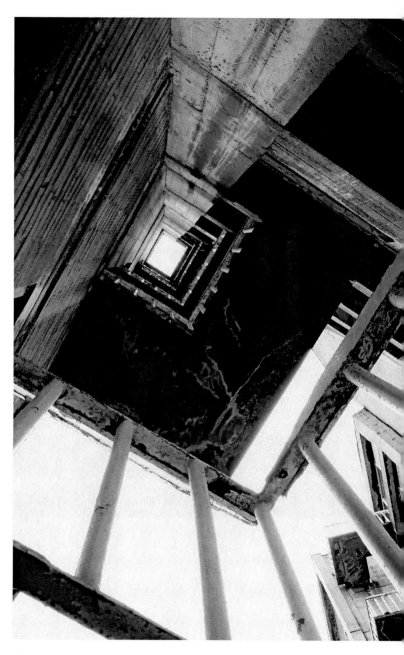

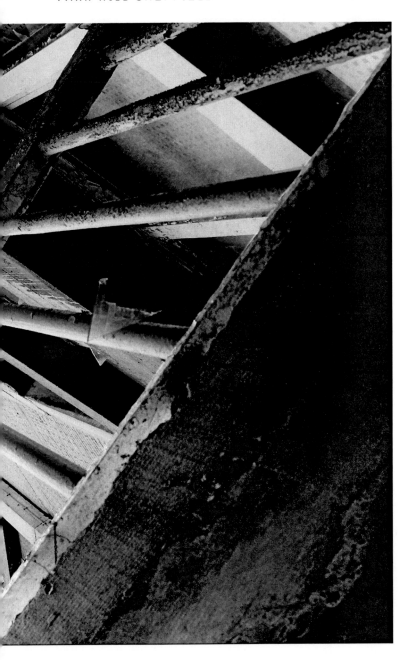

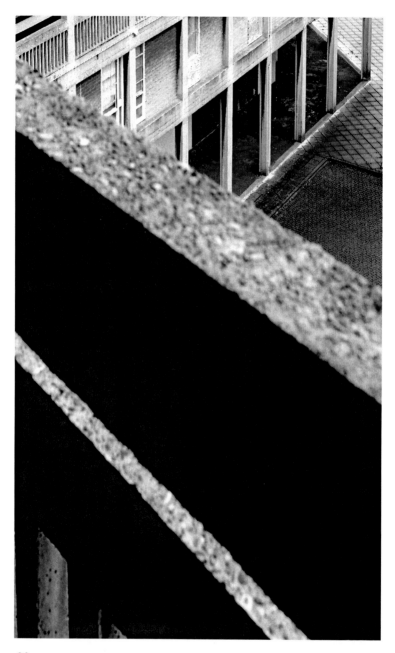

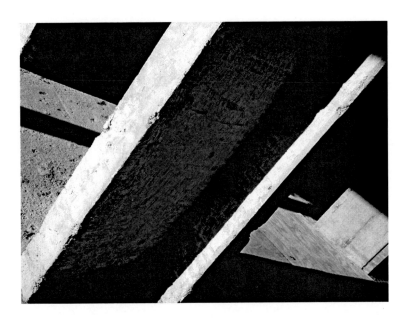

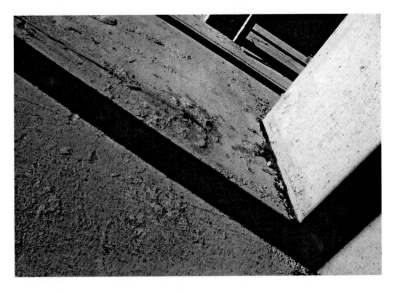

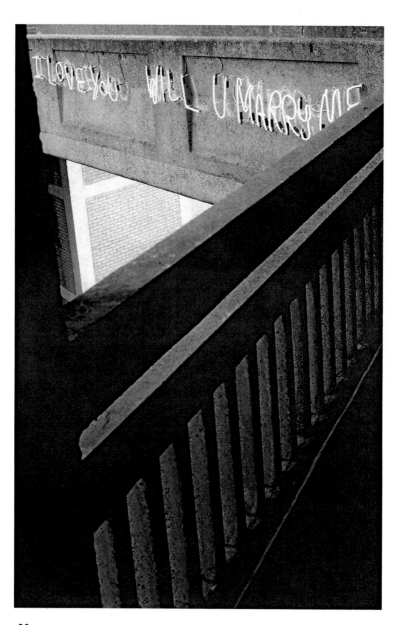

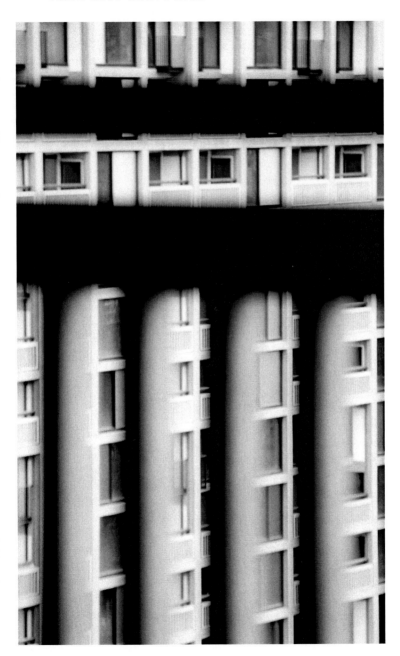

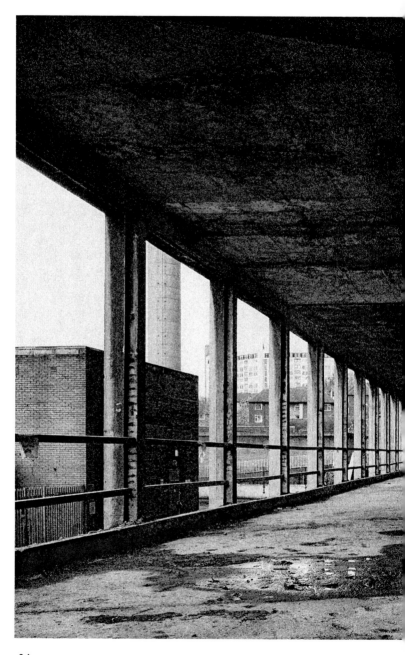

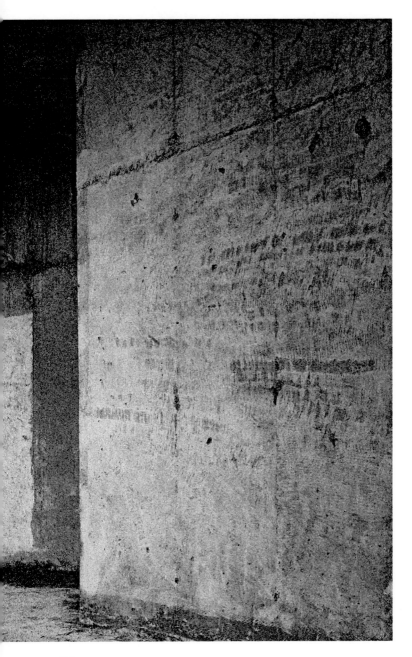

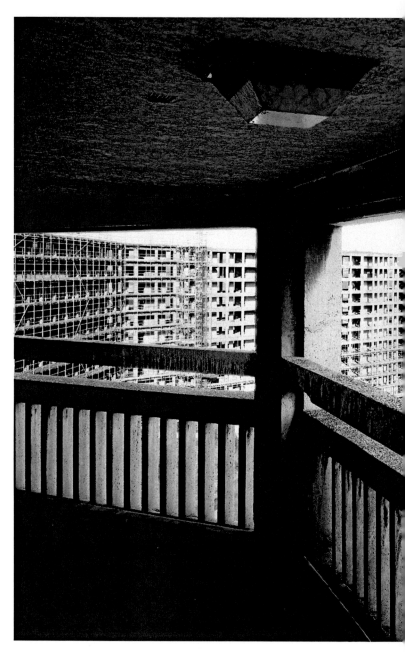

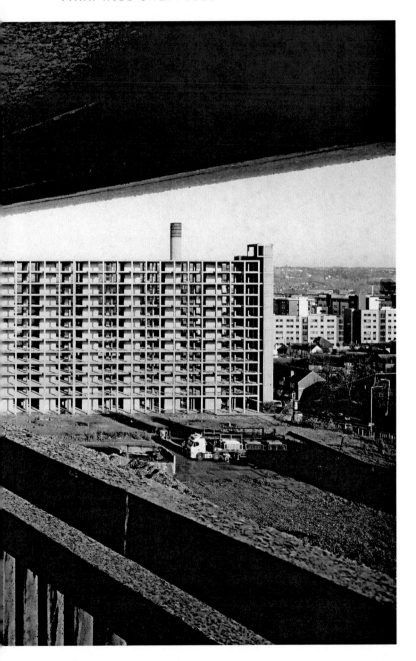

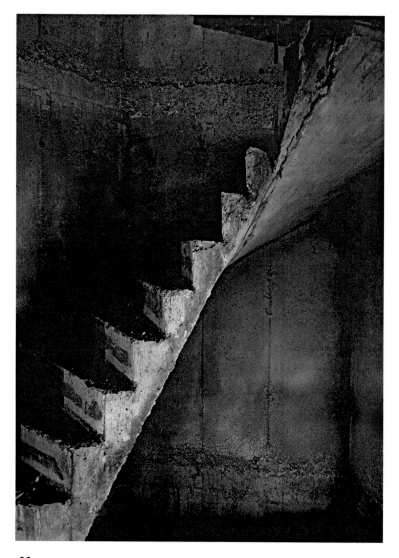

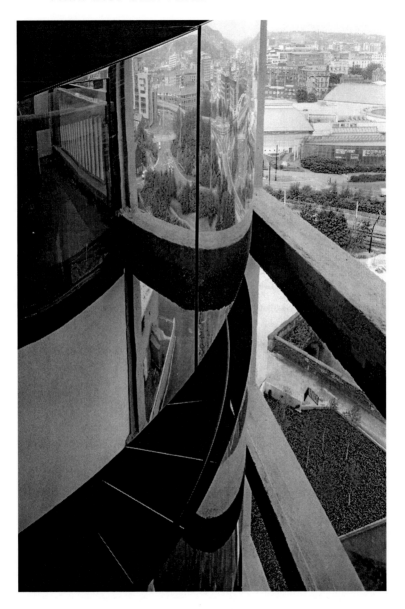

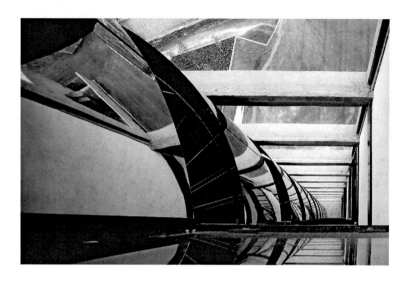

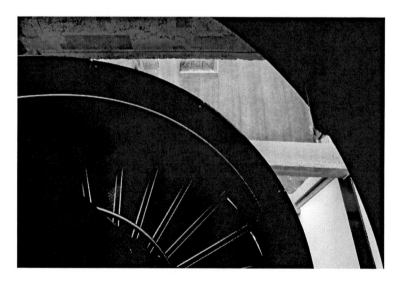

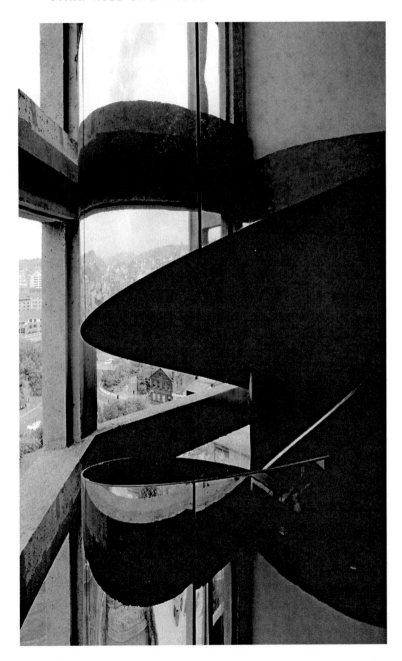

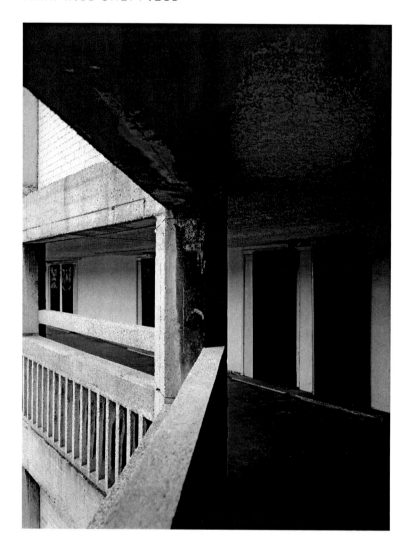

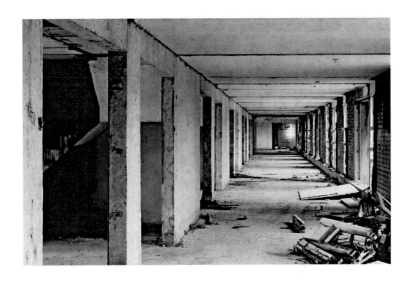

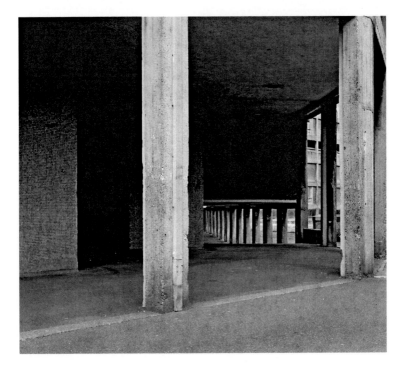

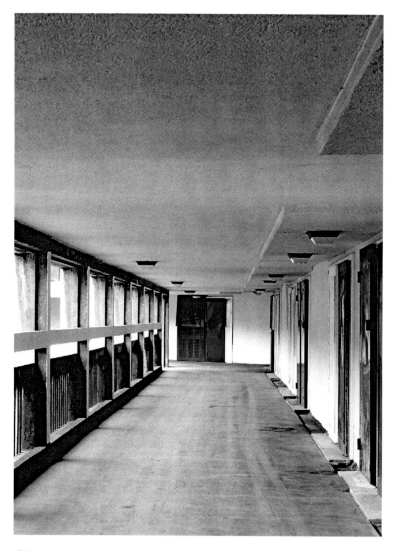

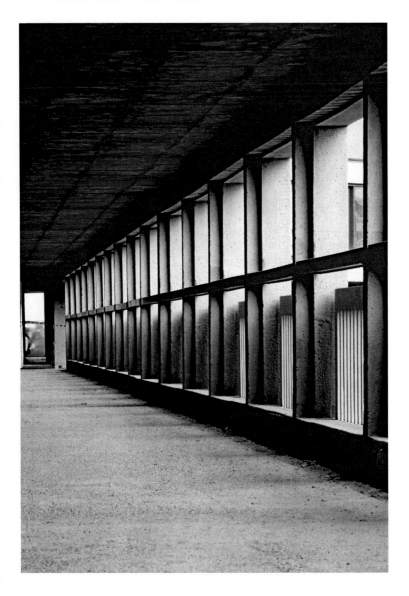

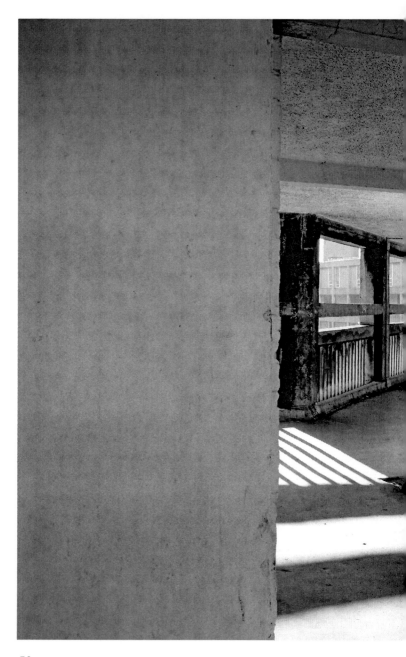

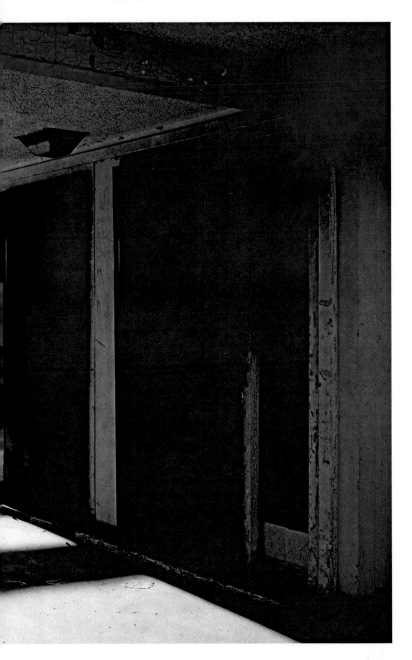

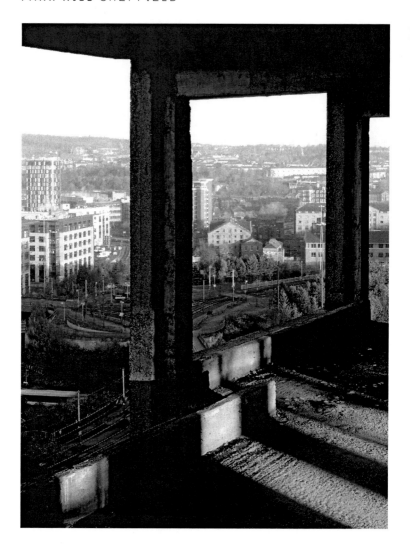

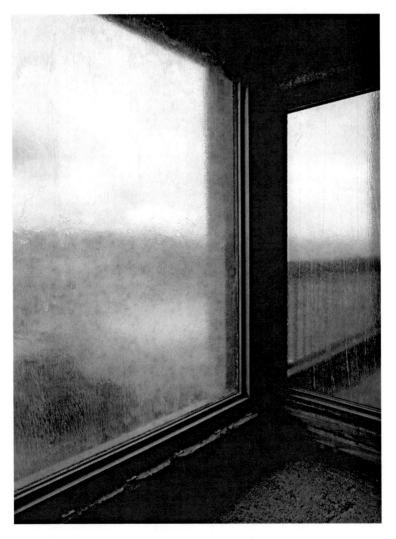

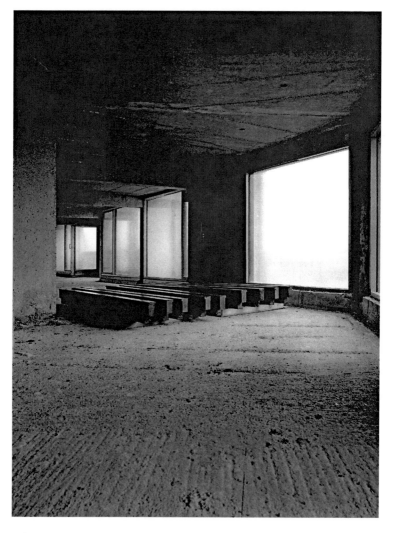

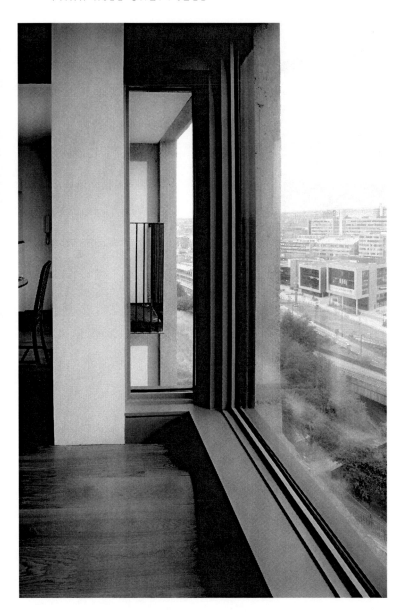

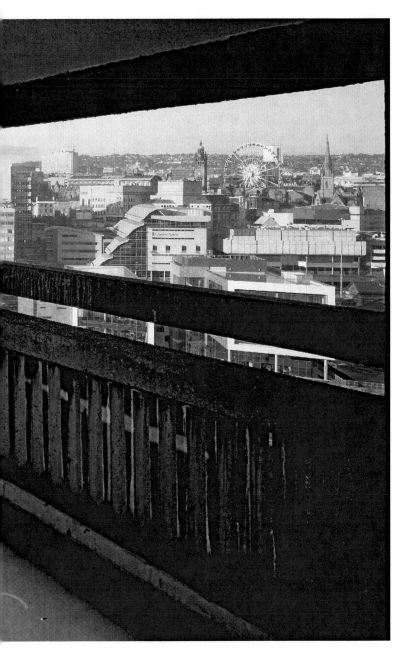

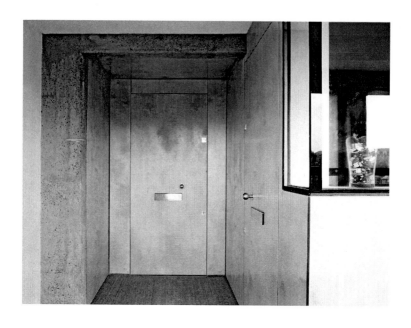

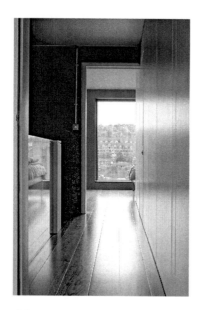

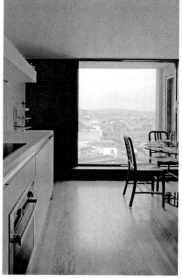

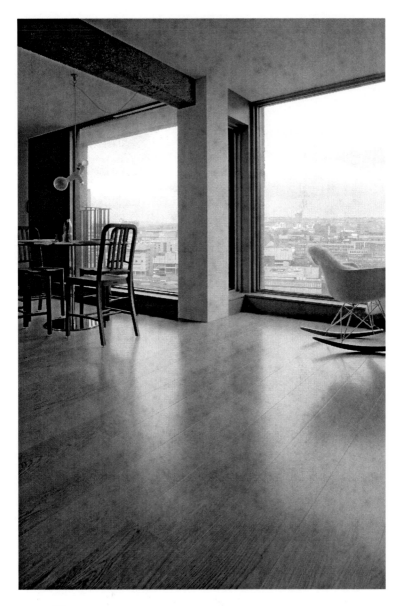

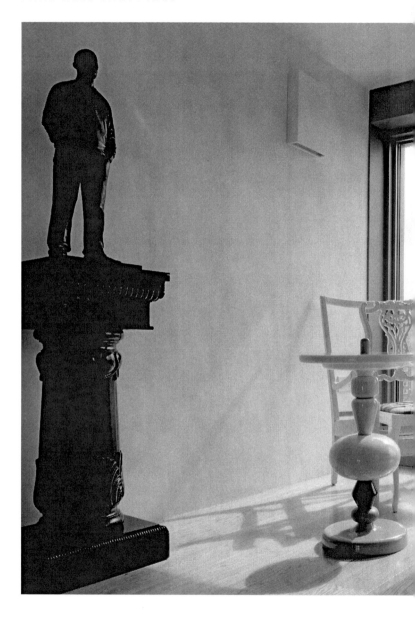

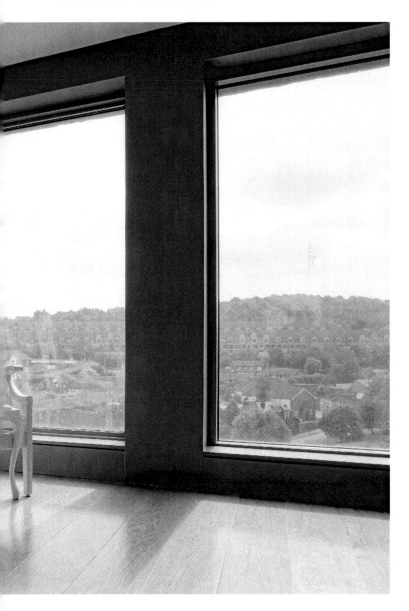

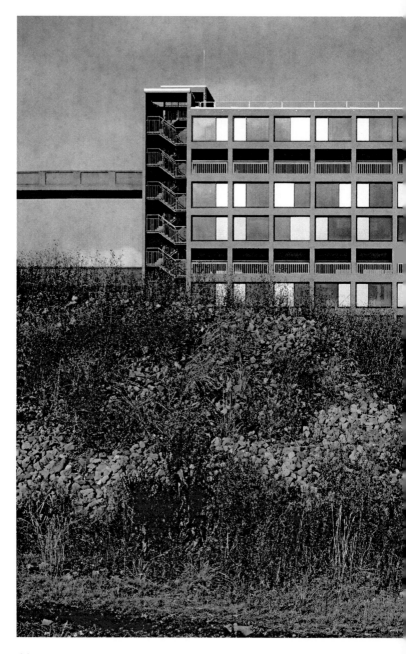

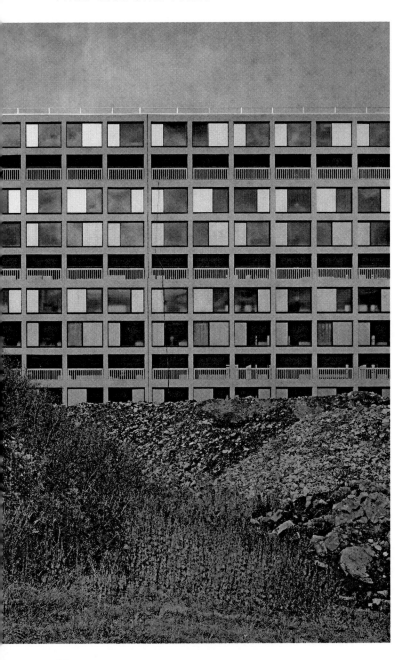

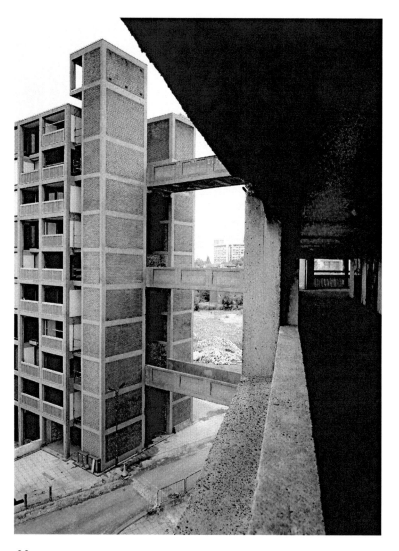

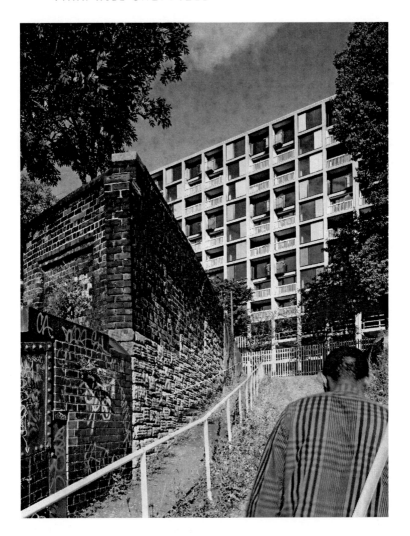

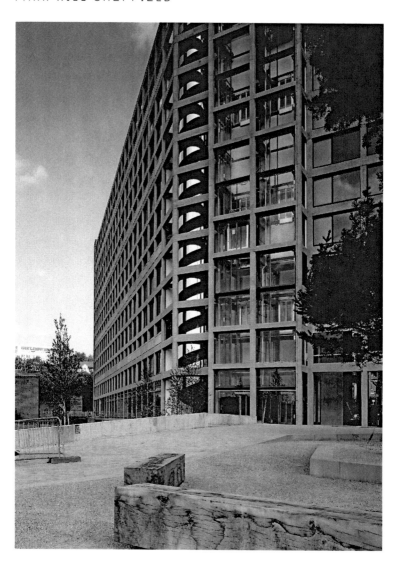

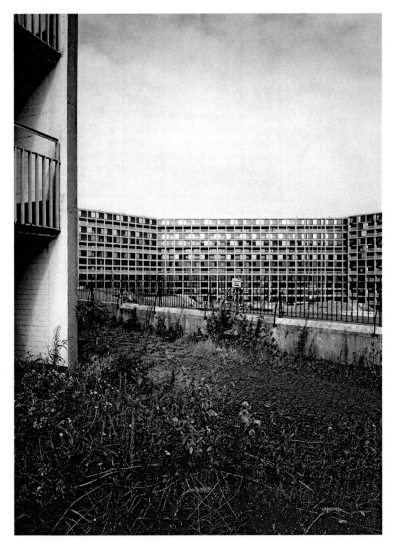

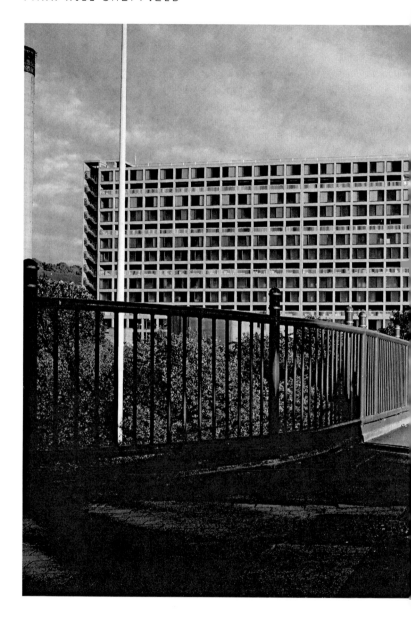

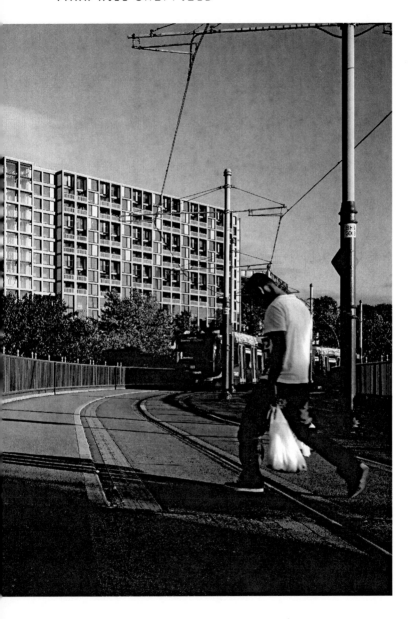

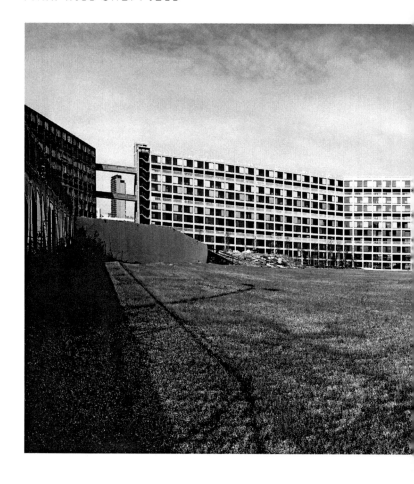

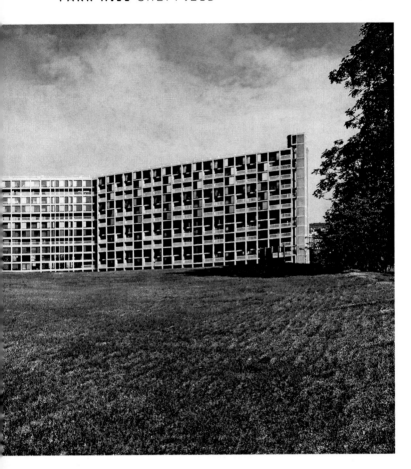

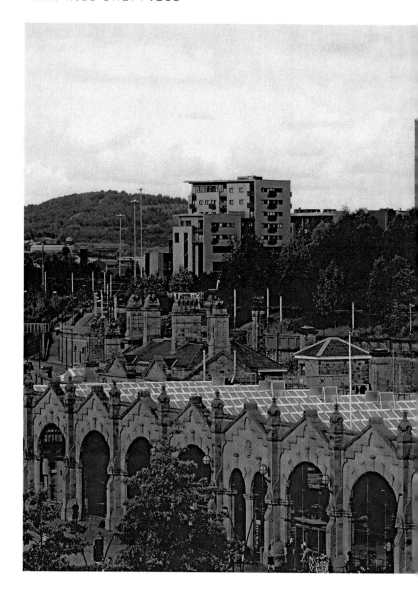

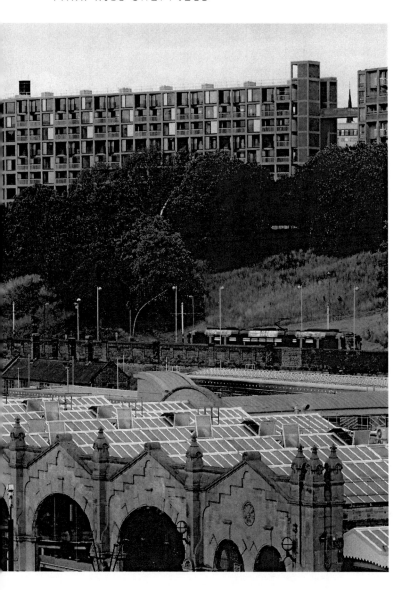

I HOPE YOU'RE PHOTOGRAPHING THIS IN BLACK
AND WHITE; IT'S GRIM UP HERE.

PARK HILL RESIDENT

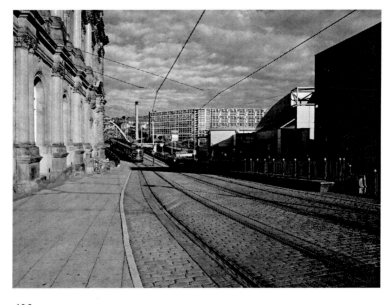